FLIP a
Funny Farm

Color Your Own Cartoon!

John Kurtz

Dover Publications, Inc.
Mineola, New York

Bibliographical Note

FLIP OUTS Funny Farm: Color Your Own Cartoon! is a new work,
first published by Dover Publications, Inc., in 2015.

International Standard Book Number

ISBN-13: 978-0-486-79483-9
ISBN-10: 0-486-79483-0

Manufactured in the United States by Courier Corporation
79483001 2015
www.doverpublications.com

Get ready to make your own flip book! A flip book is a series of cartoon images that tell a story when you "flip" through the pages with your thumb. In this little book, you flip the pages from front to back and get one cartoon series. Flip it from back to front and you get a second series! Add to the fun by coloring in the pages any way you wish.

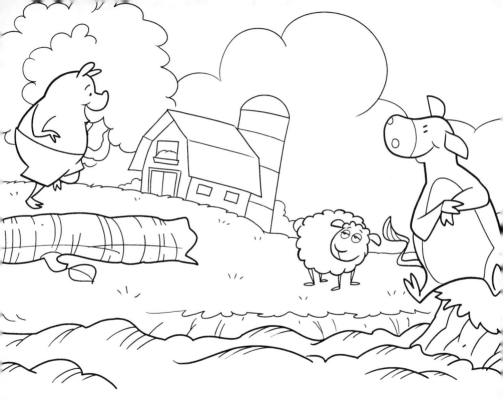

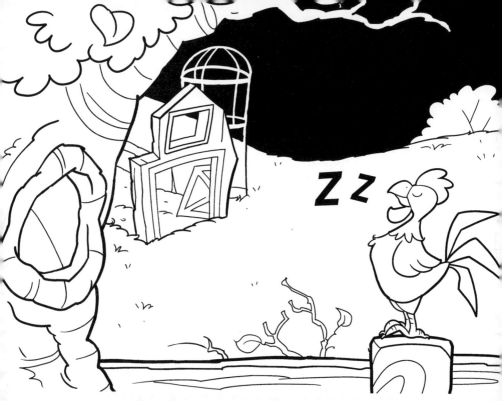

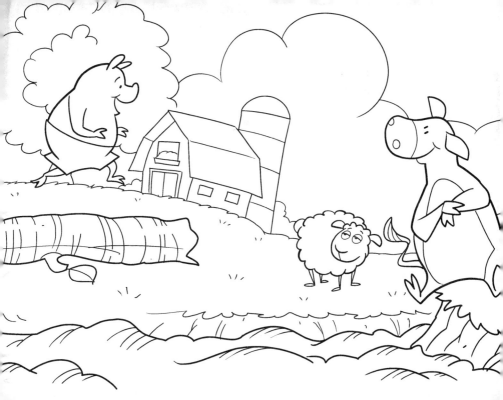

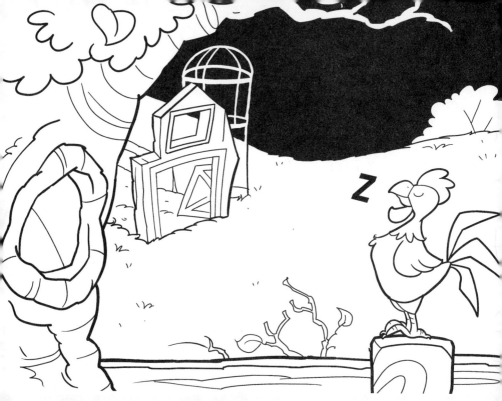

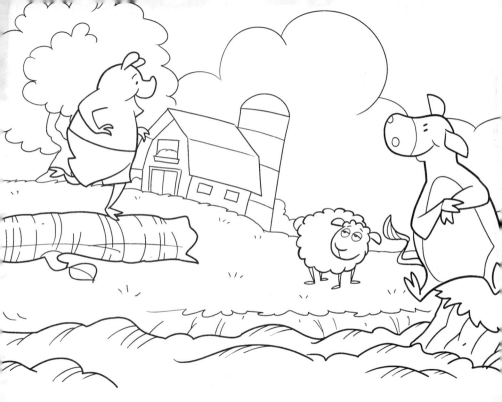

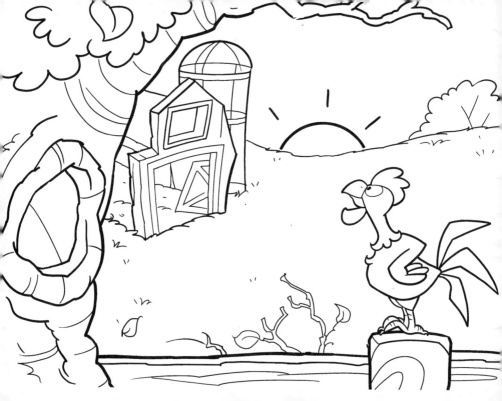

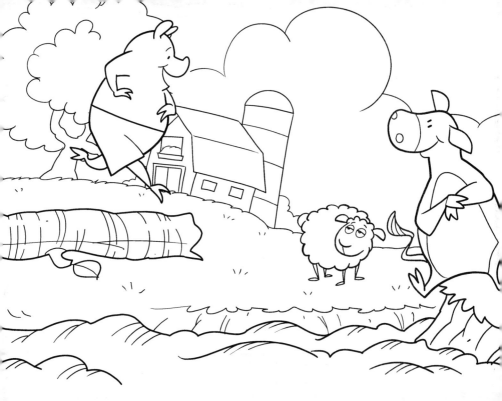

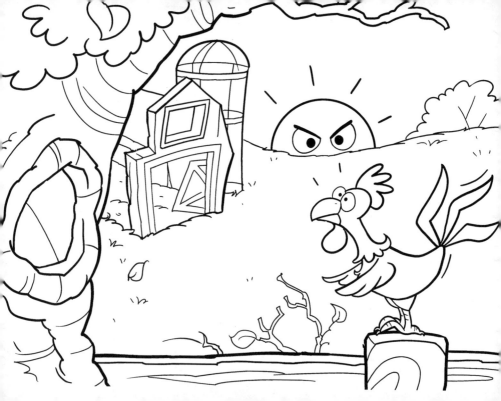

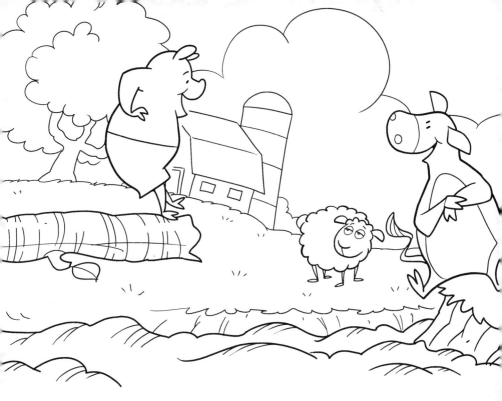

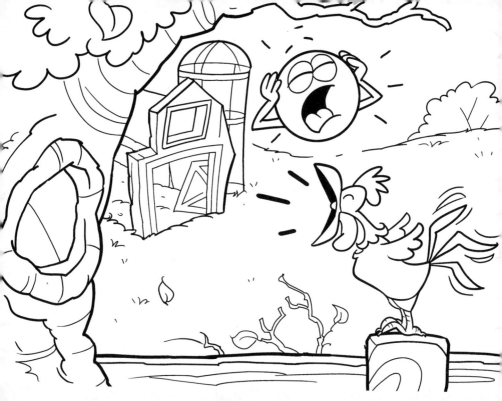

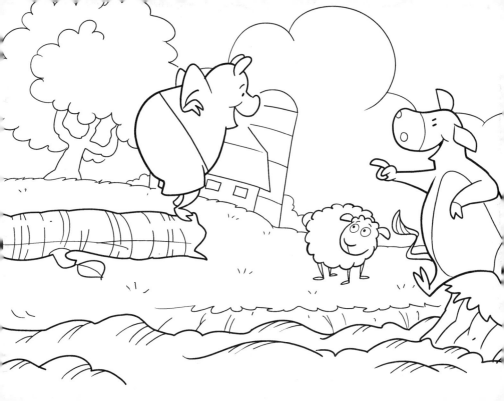

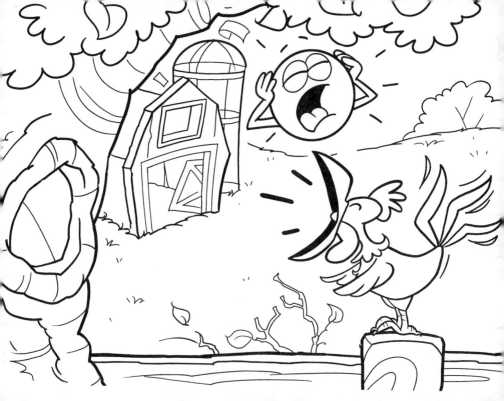

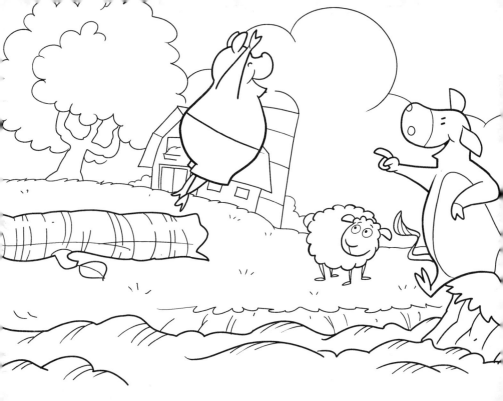

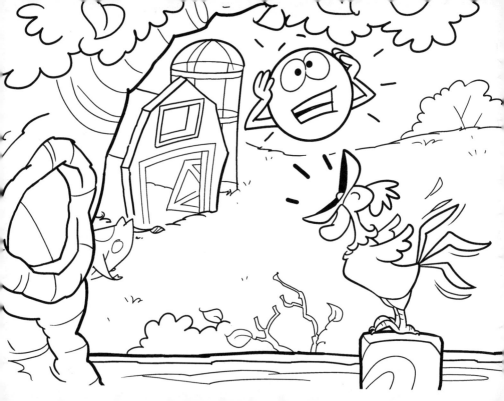

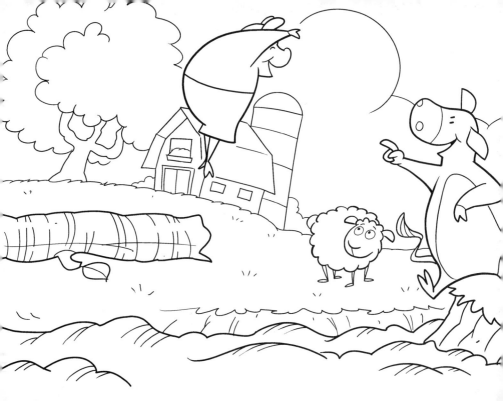

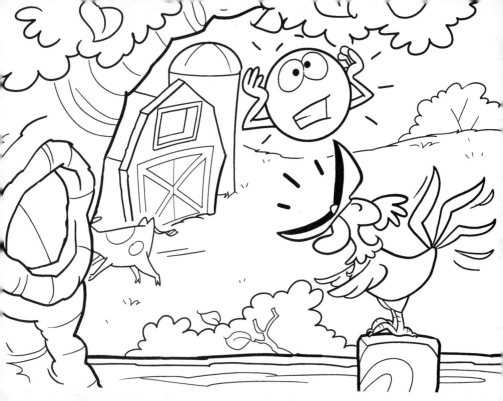

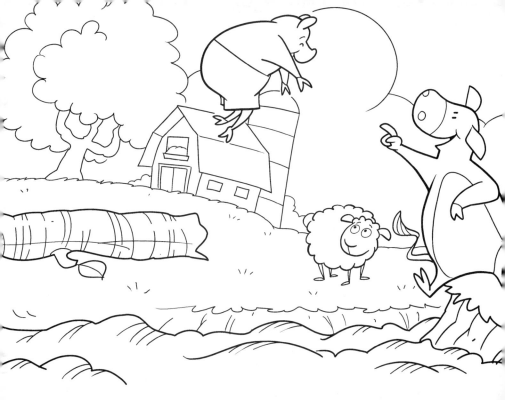

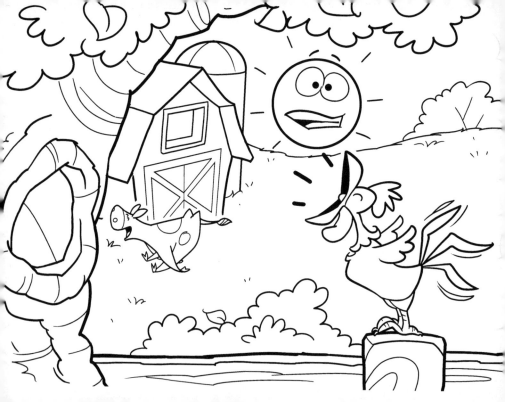

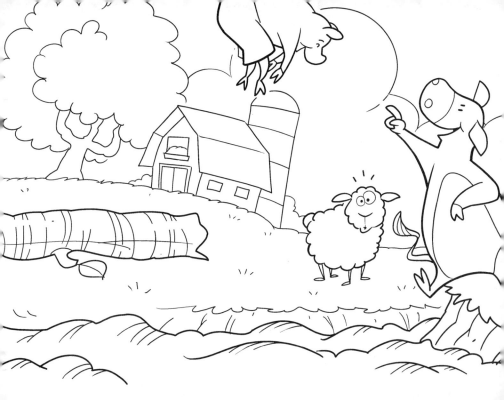

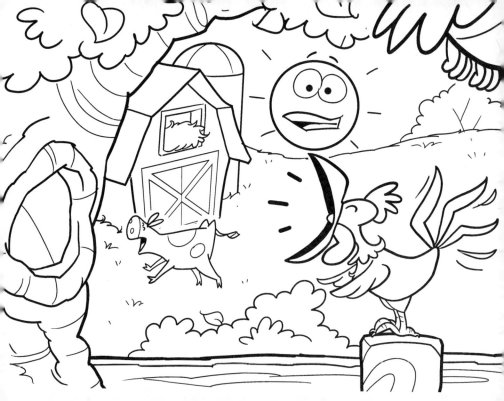

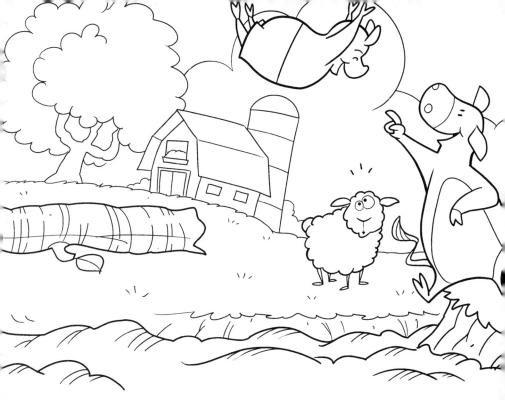

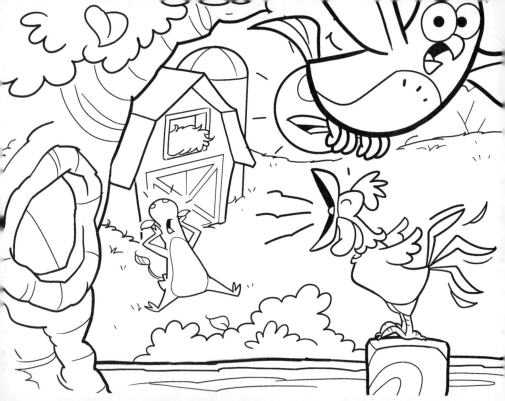

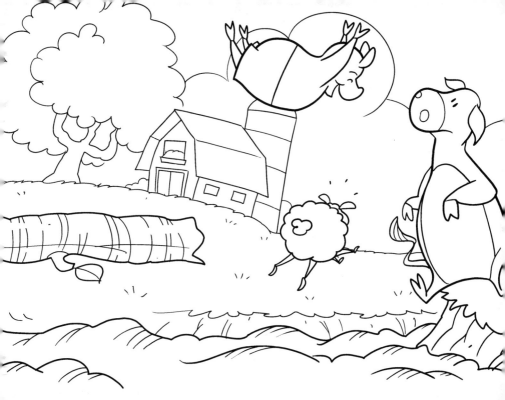

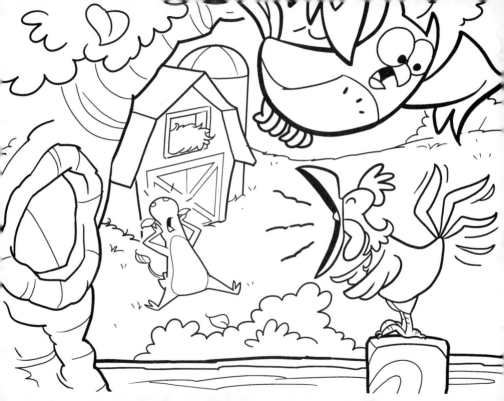

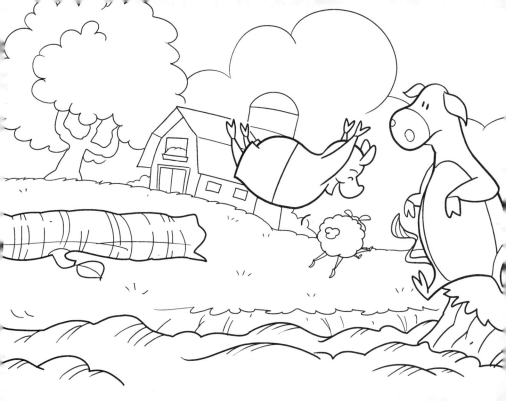

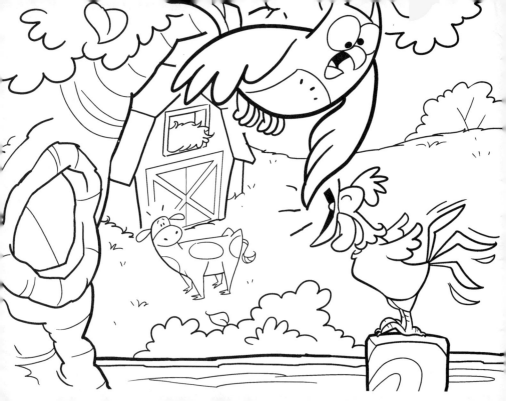

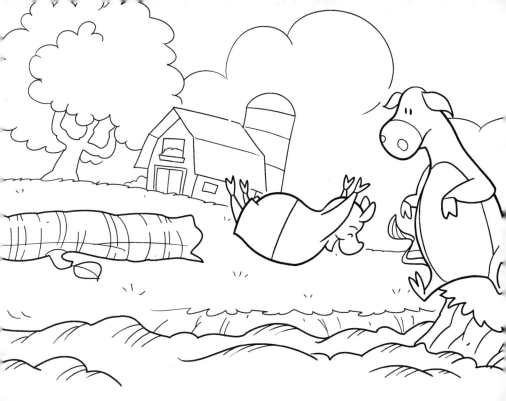

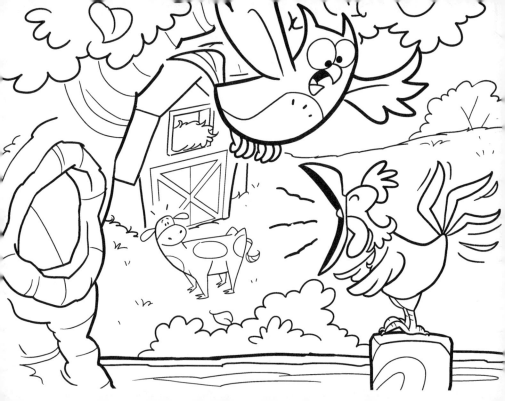

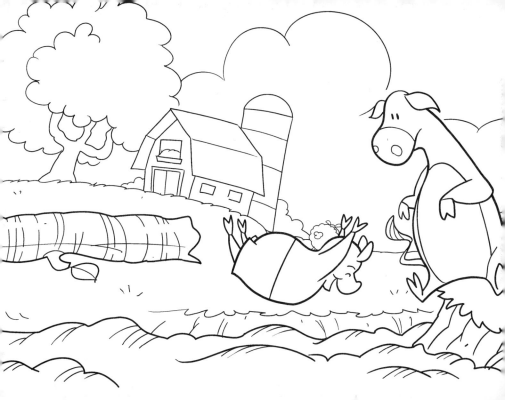

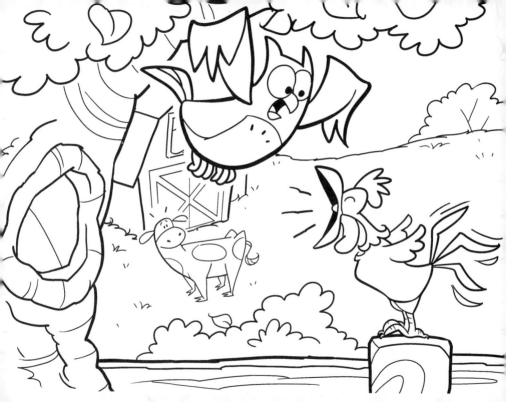

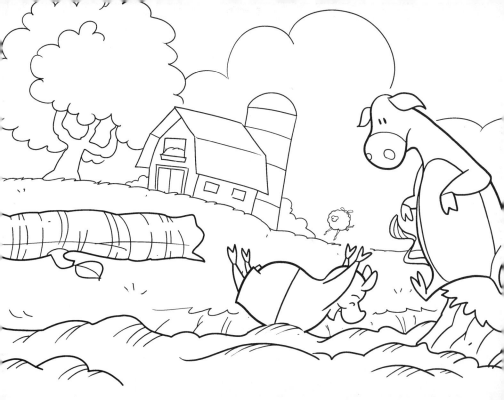

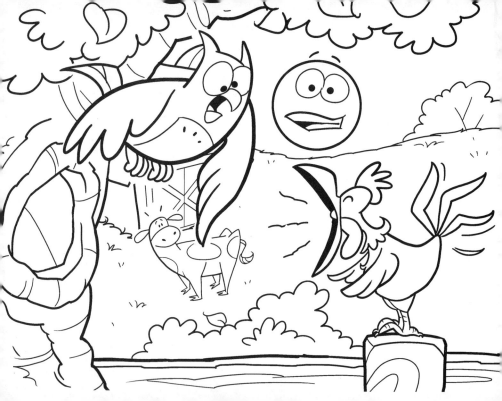

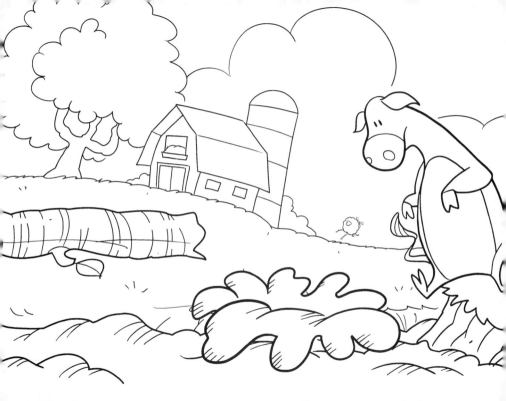

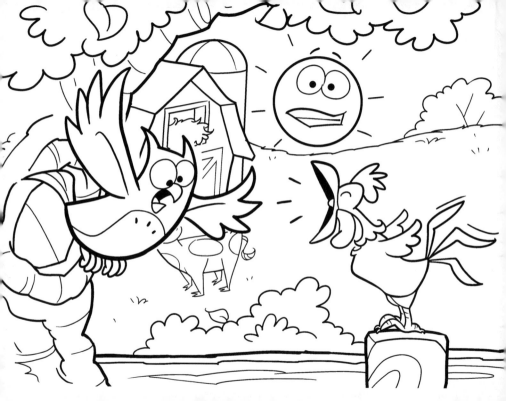

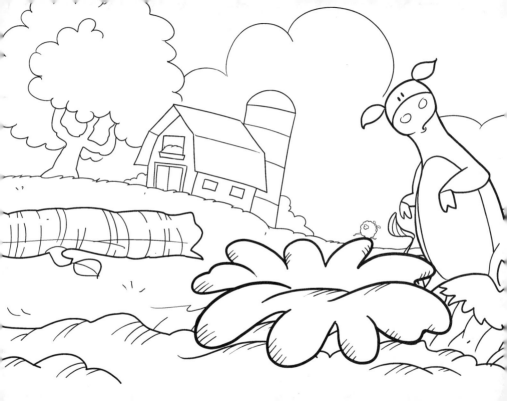

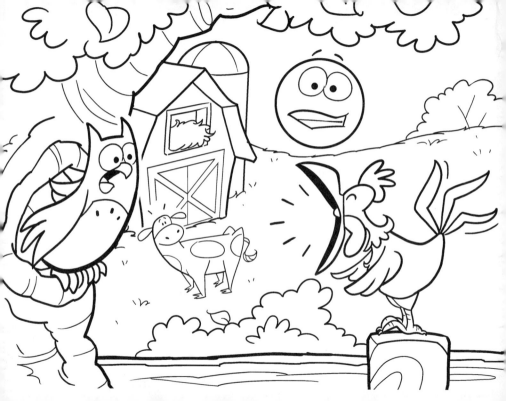

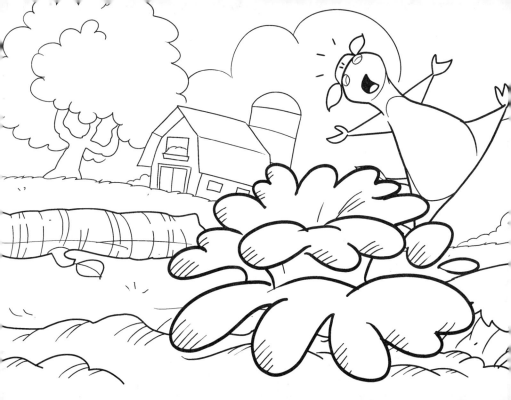

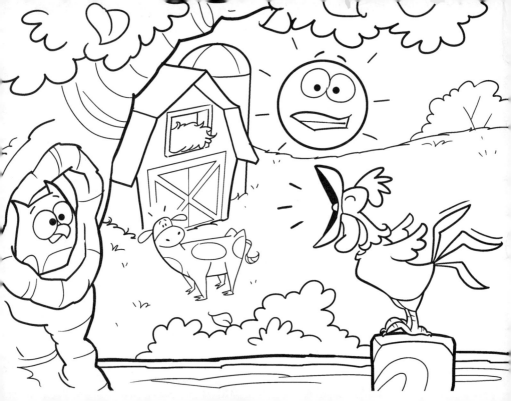

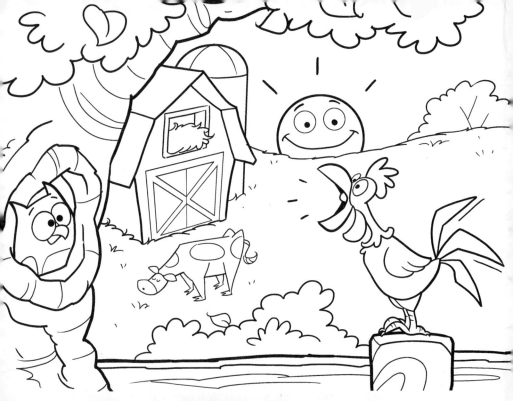

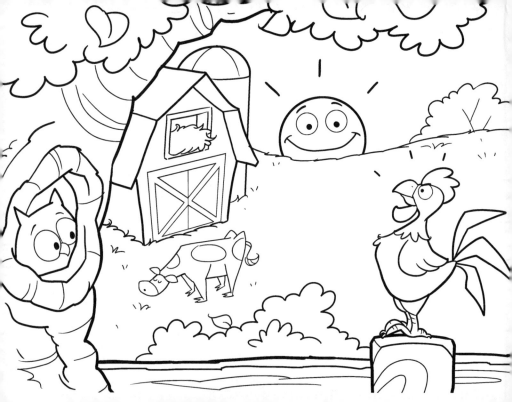

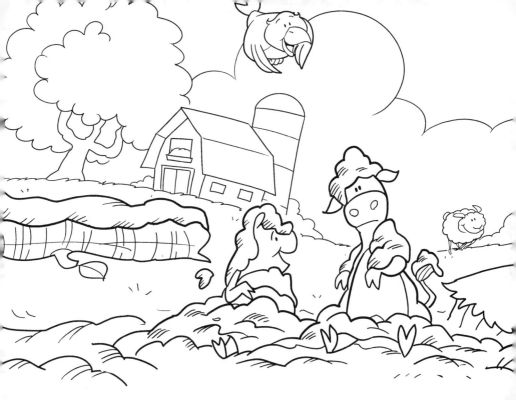

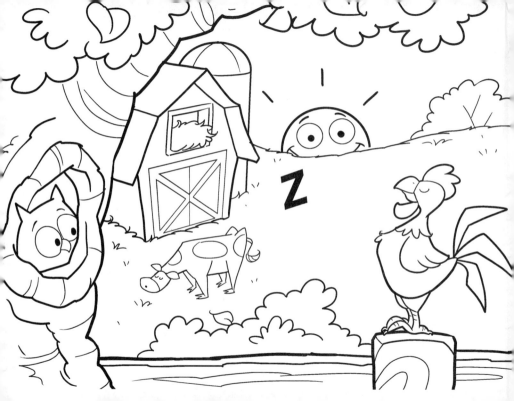

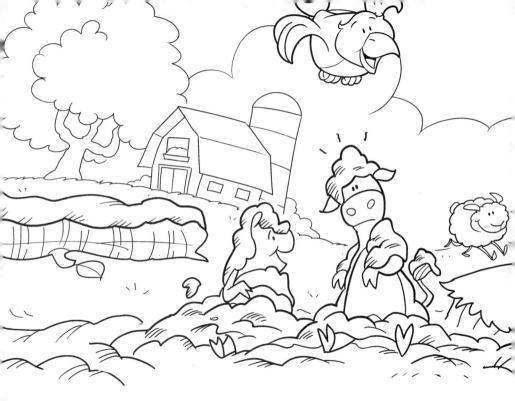

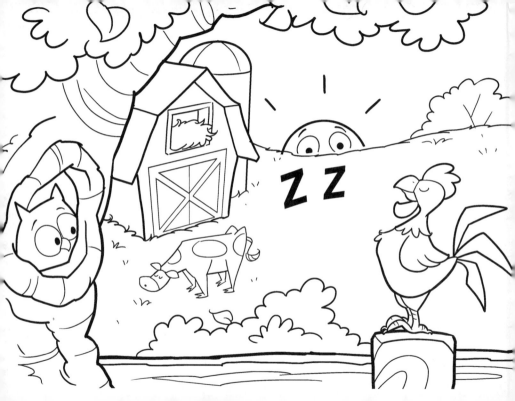

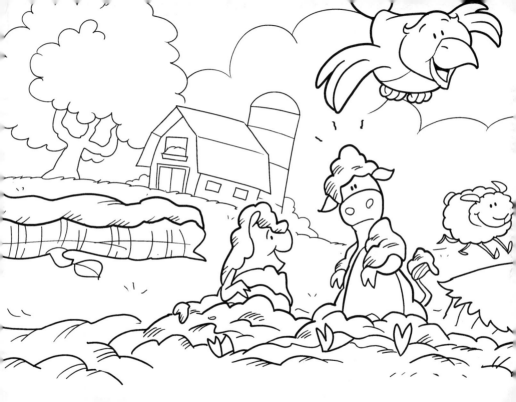

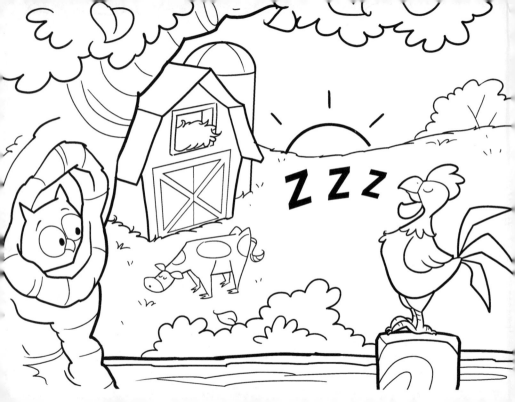

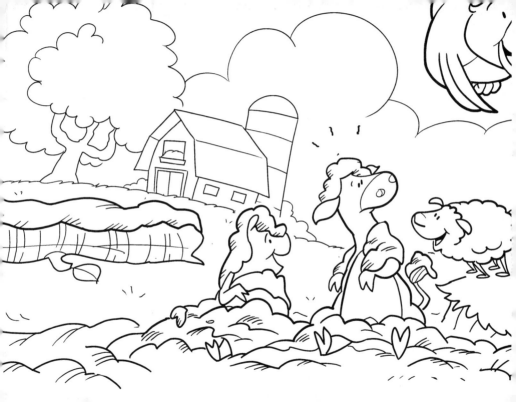

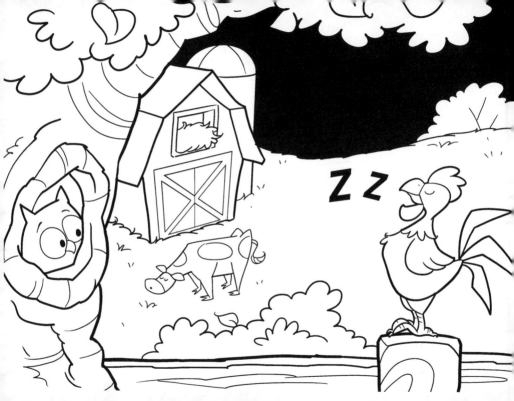